Christmas Activity Book For Kids

This Christmas Activity book belongs to:

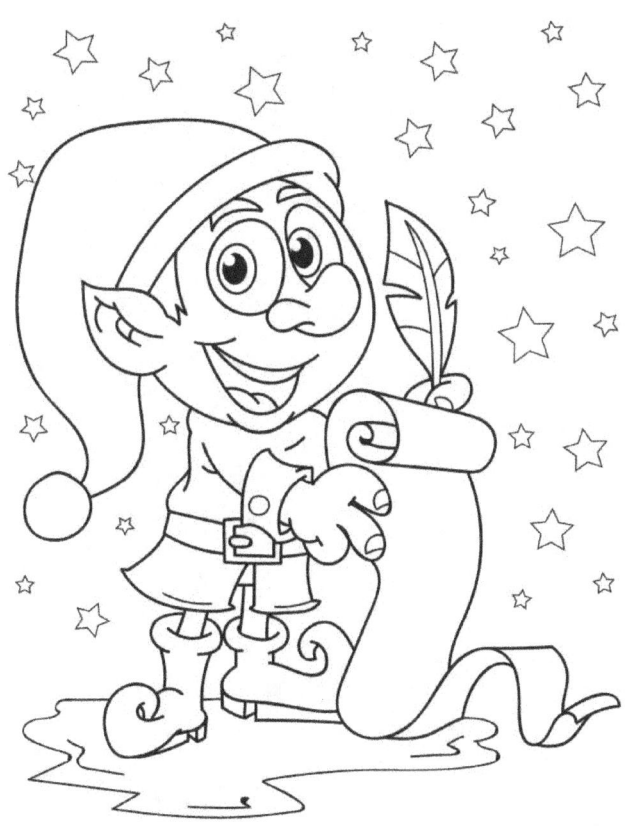

Copyright © 2019 Activity Coloring Books

Find the two identical pictures.

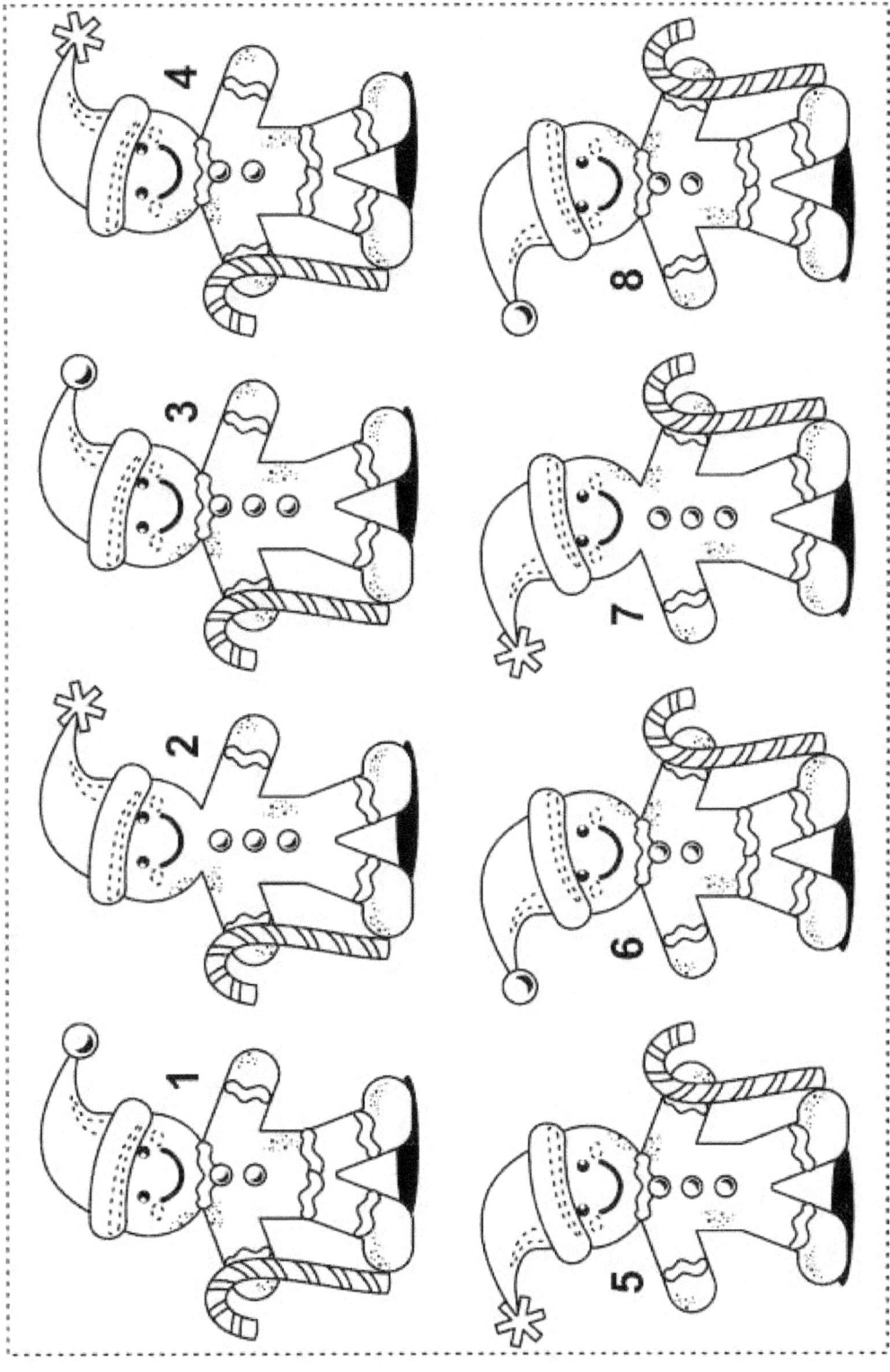

ANSWER: 6, 8.

HOW MANY?

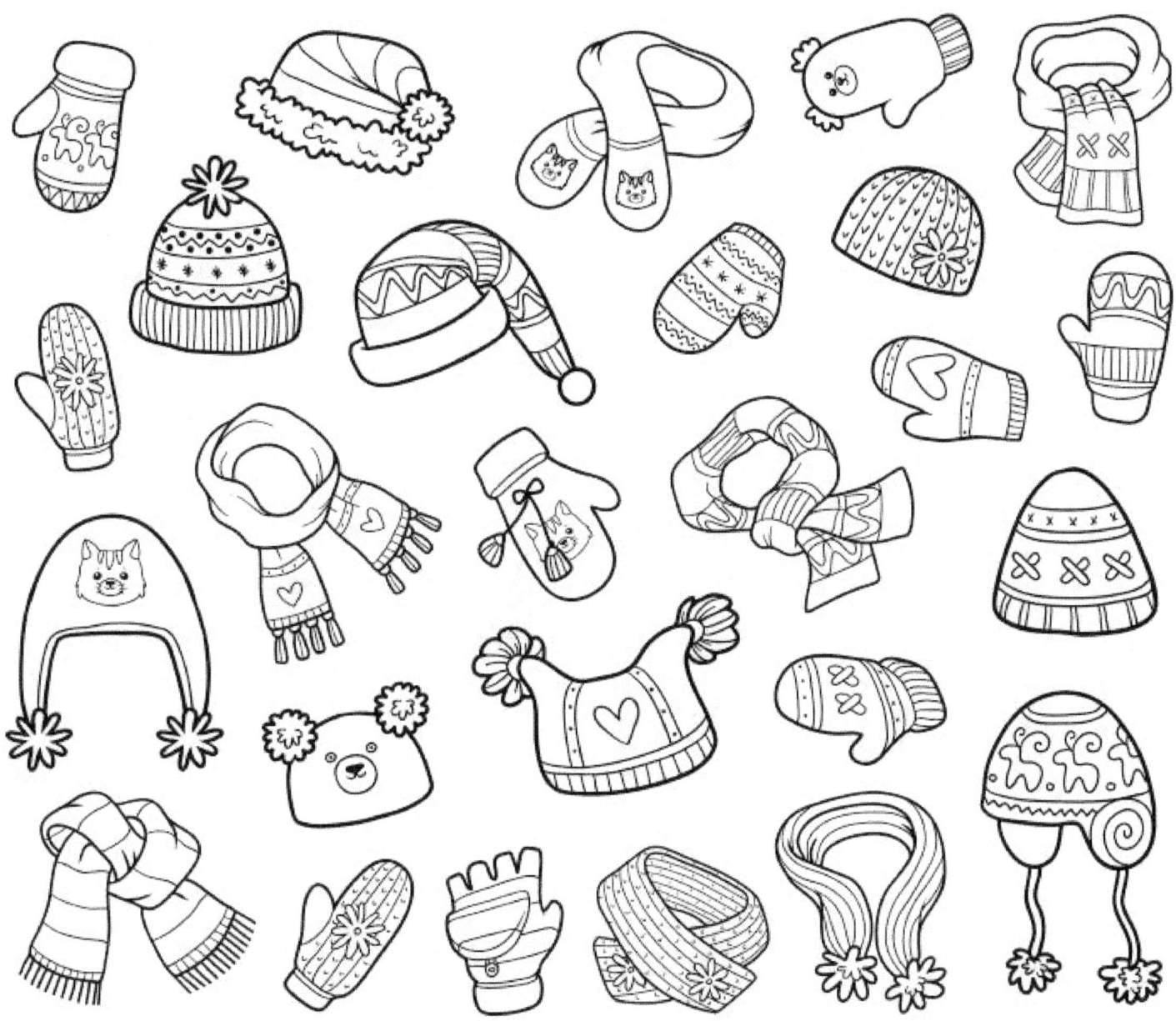

Draw a line from dot number 1 to dot number 2, then from dot number 2 to dot number 3, 3 to 4, and so on. Continue to join the dots until you have connected all the numbered dots. Then color the picture!

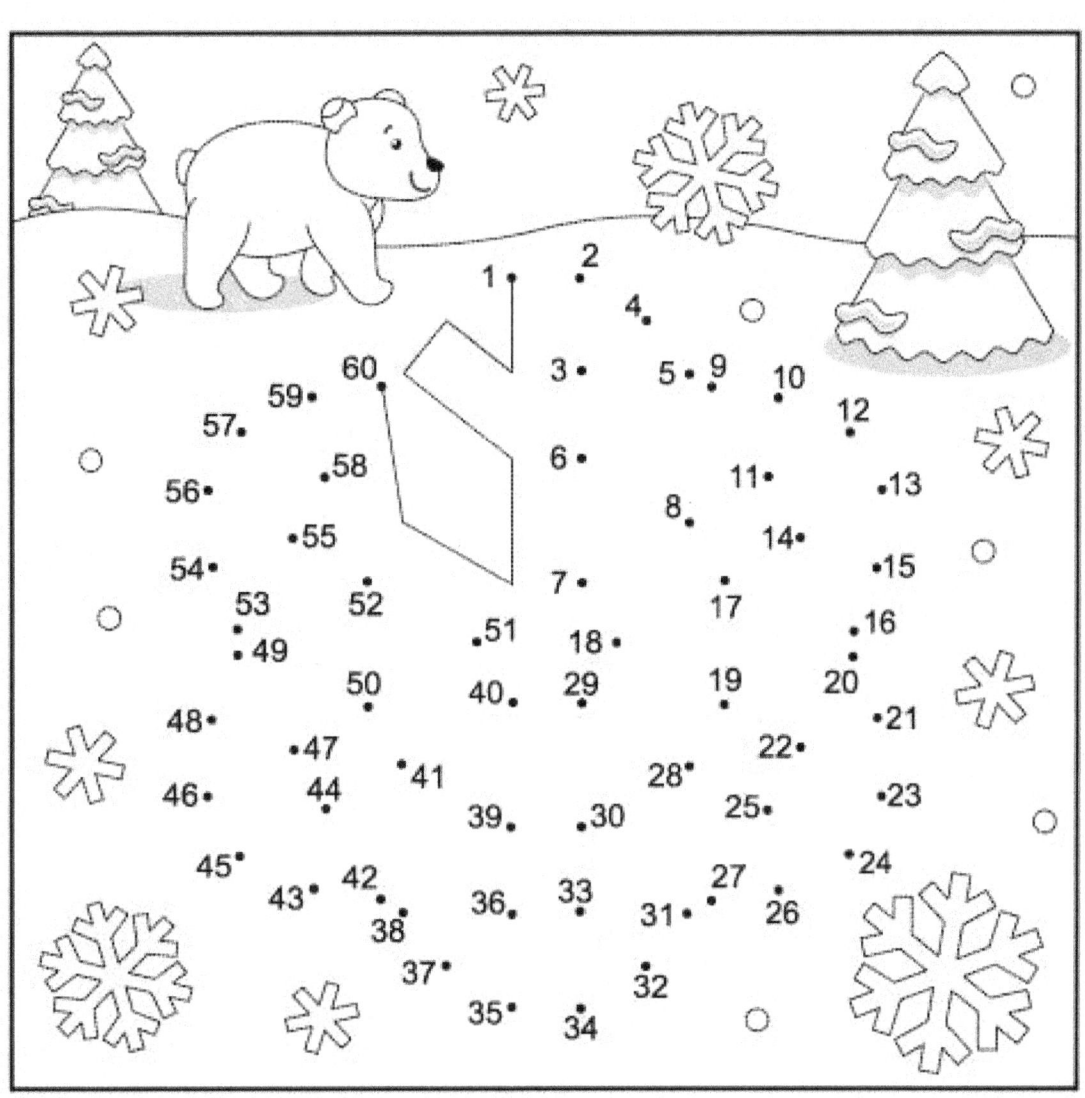

ANSWER: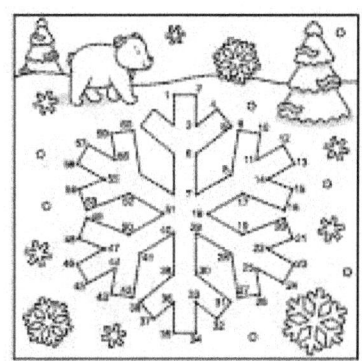

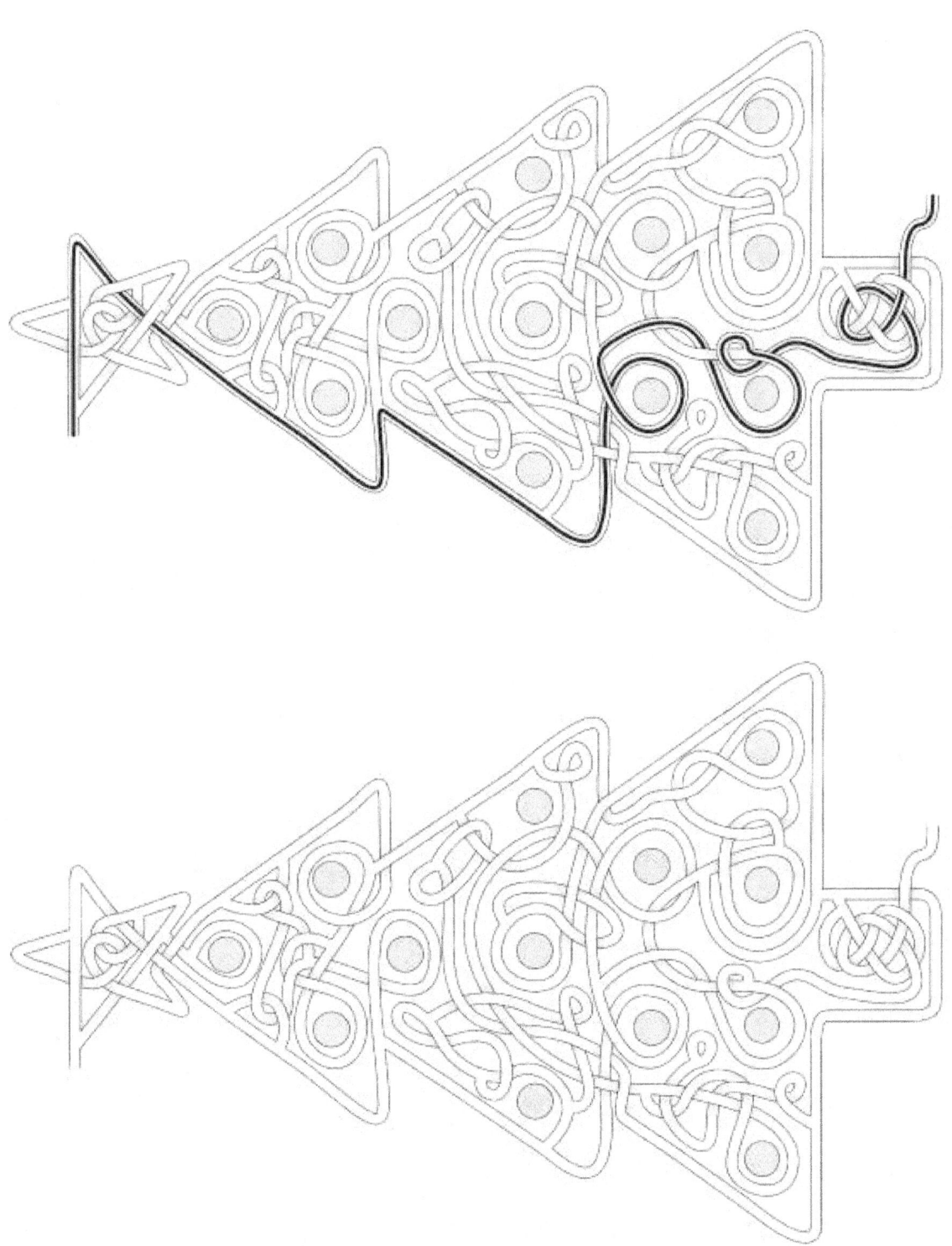

The same number represents the same letter. Crack the code and fill the grid. To help you get started some word entries have picture clues.

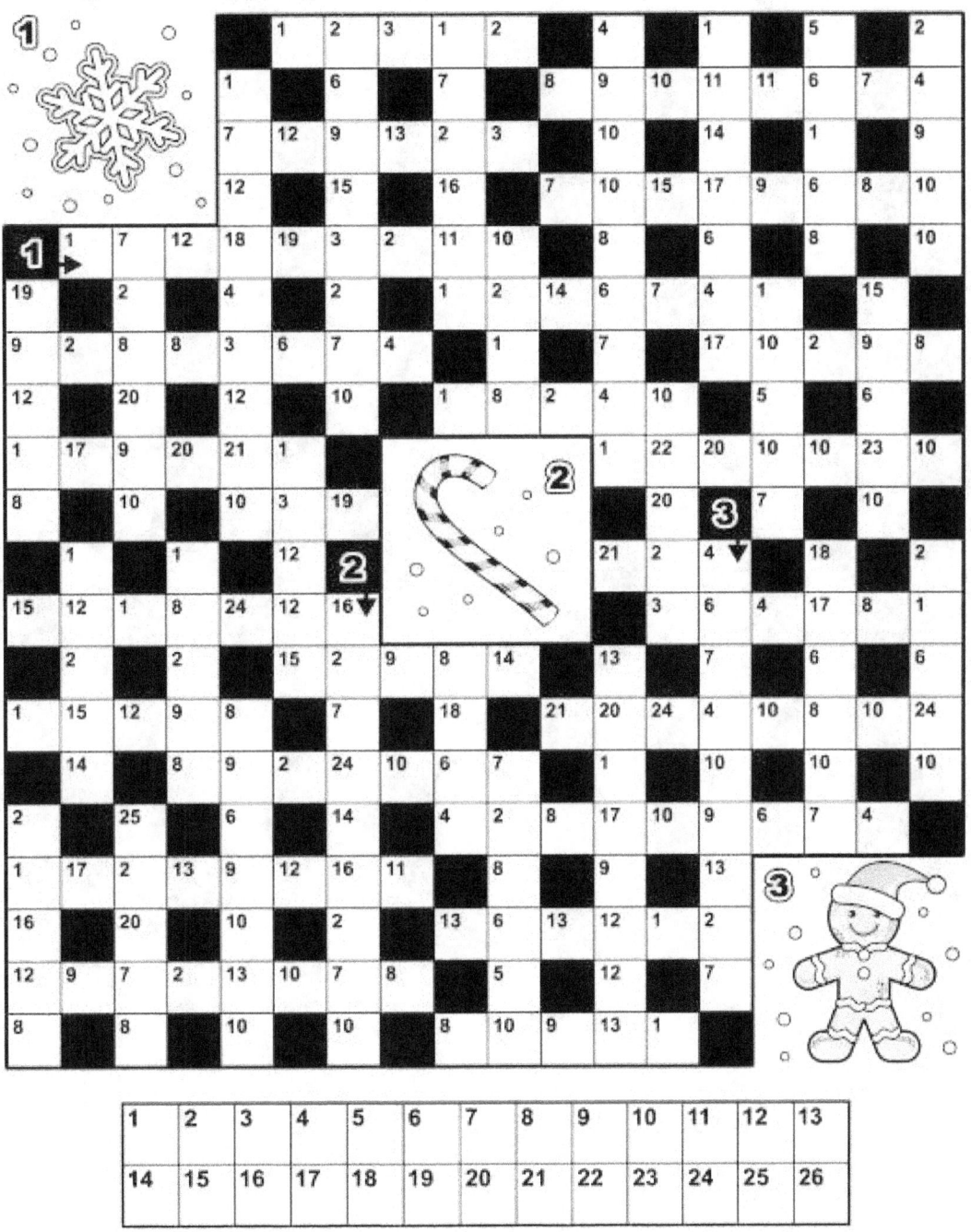

1	2	3	4	5	6	7	8	9	10	11	12	13
14	15	16	17	18	19	20	21	22	23	24	25	26

ANSWER: 1=S, 2=A, 3=L, 4=G, 5=V, 6=I, 7=N, 8=T, 9=R, 10=E, 11=K, 12=O, 13=M, 14=Y, 15=P, 16=C, 17=H, 18=W, 19=F, 20=U, 21=B, 22=O, 23=Z, 24=D, 25=J, 26=X.

Draw a line from dot number 1 to dot number 2, then from dot number 2 to dot number 3, 3 to 4, and so on. Continue to join the dots until you have connected all the numbered dots. Then, color the picture!

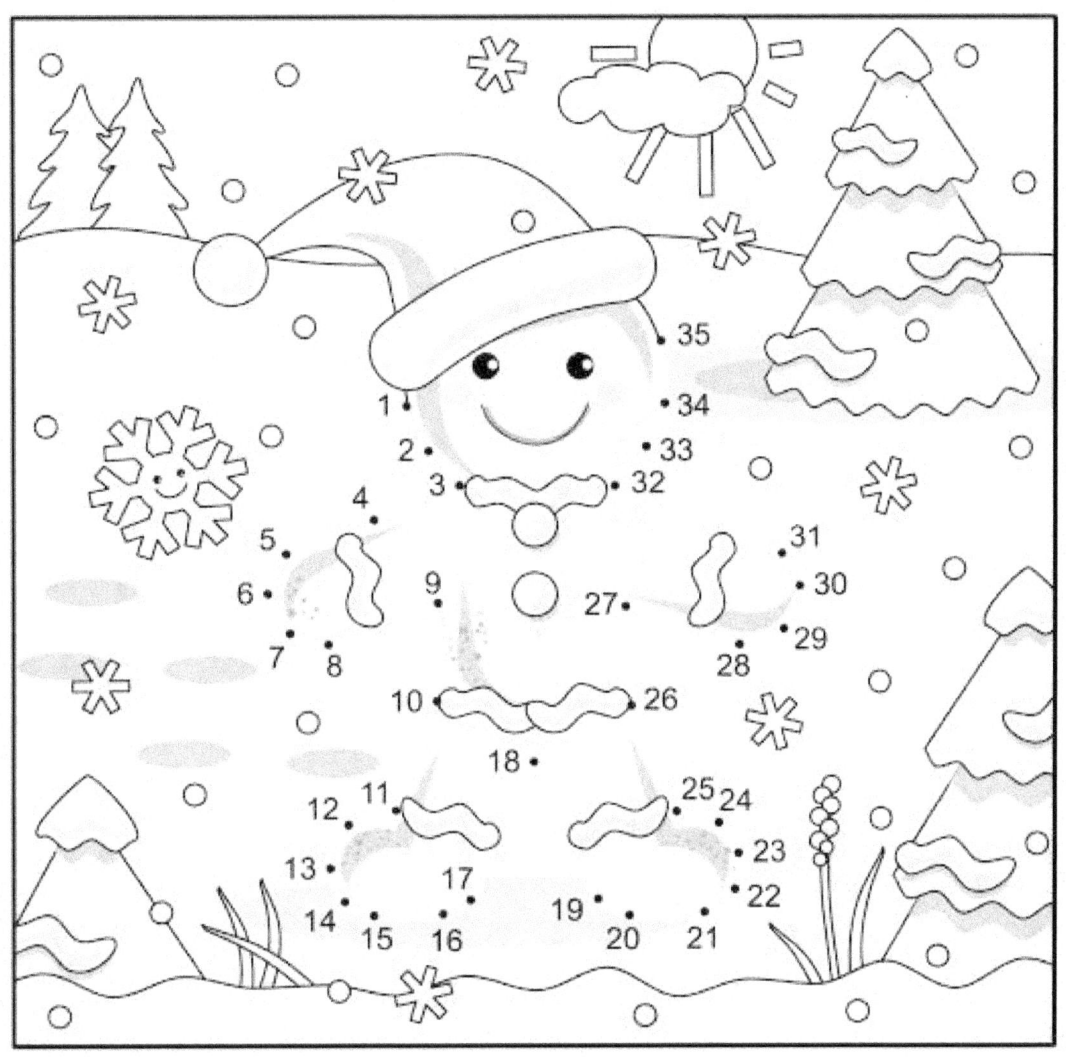

ANSWER:

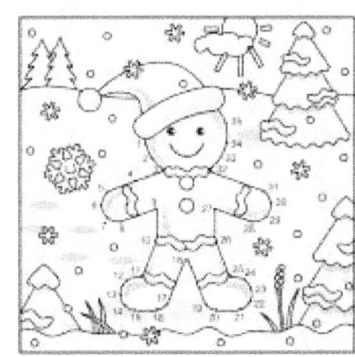

connect the dots then color in the hidden picture.

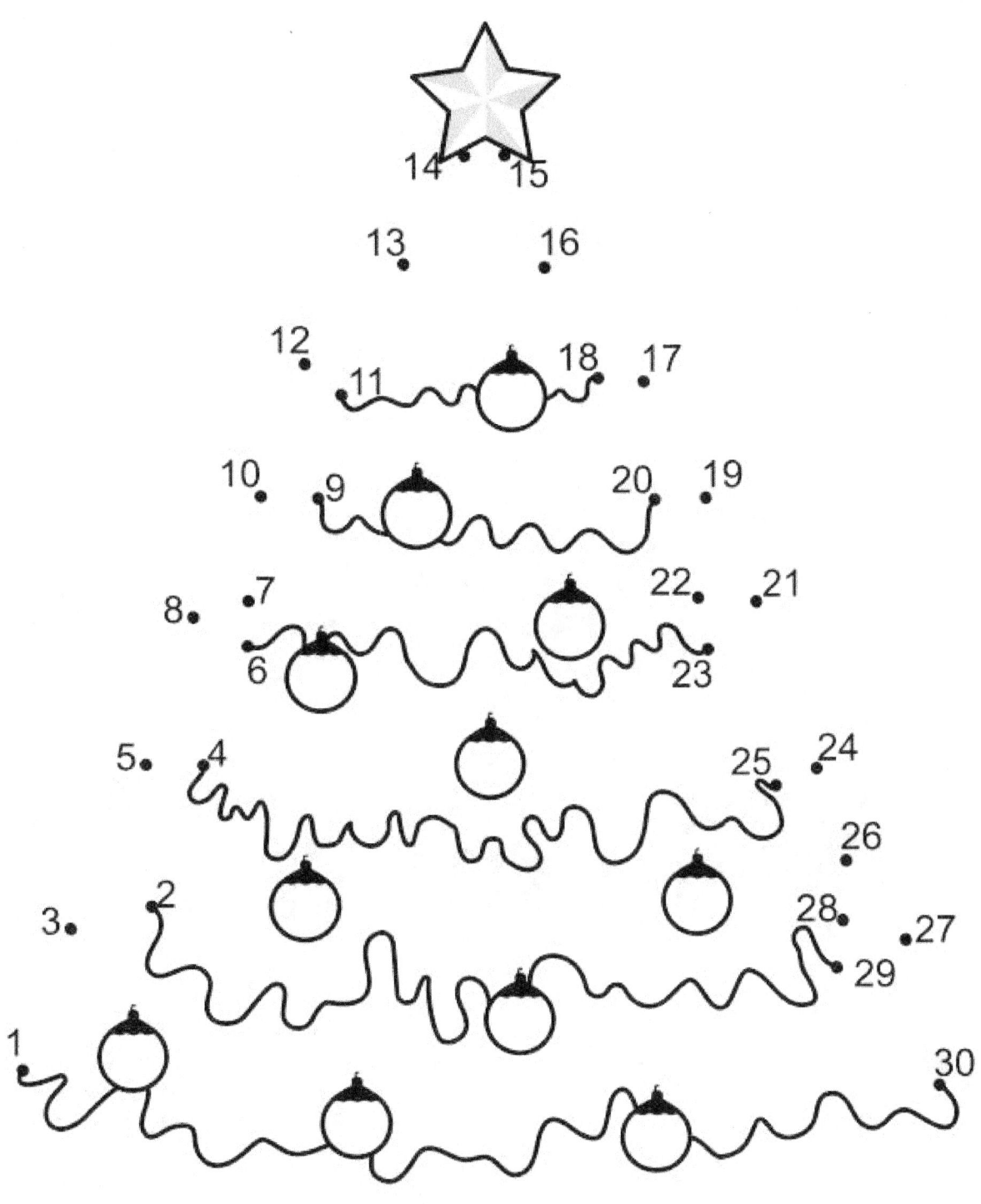

Name

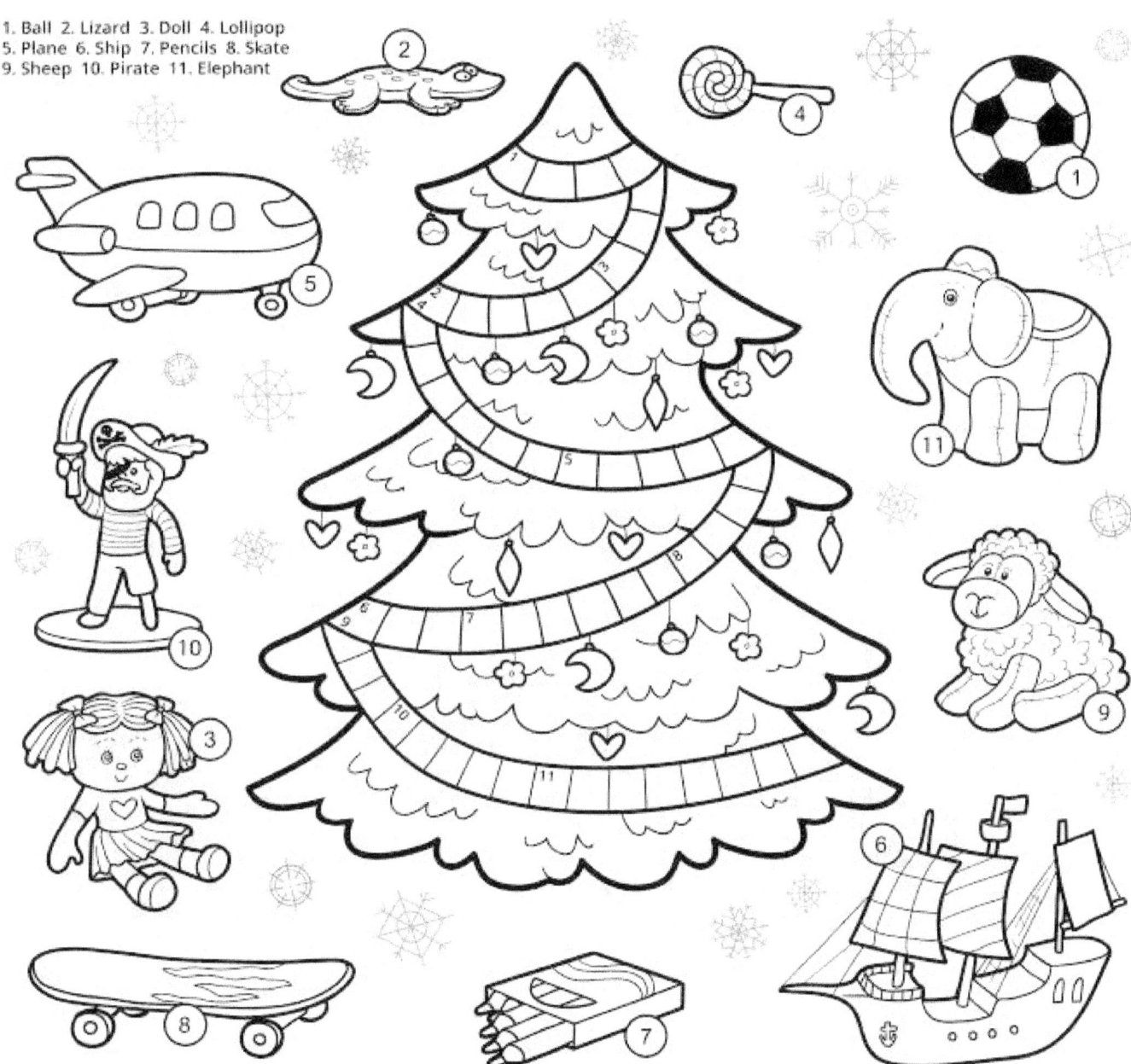

Find two the same pictures

Find two the same pictures

1. Unicorn 2. Sheep 3. Elf 4. Dress 5. Robot
6. Berry 7. Plane 8. Watch 9. Gorilla 10. Scooter
11. Santa 12. Celebration

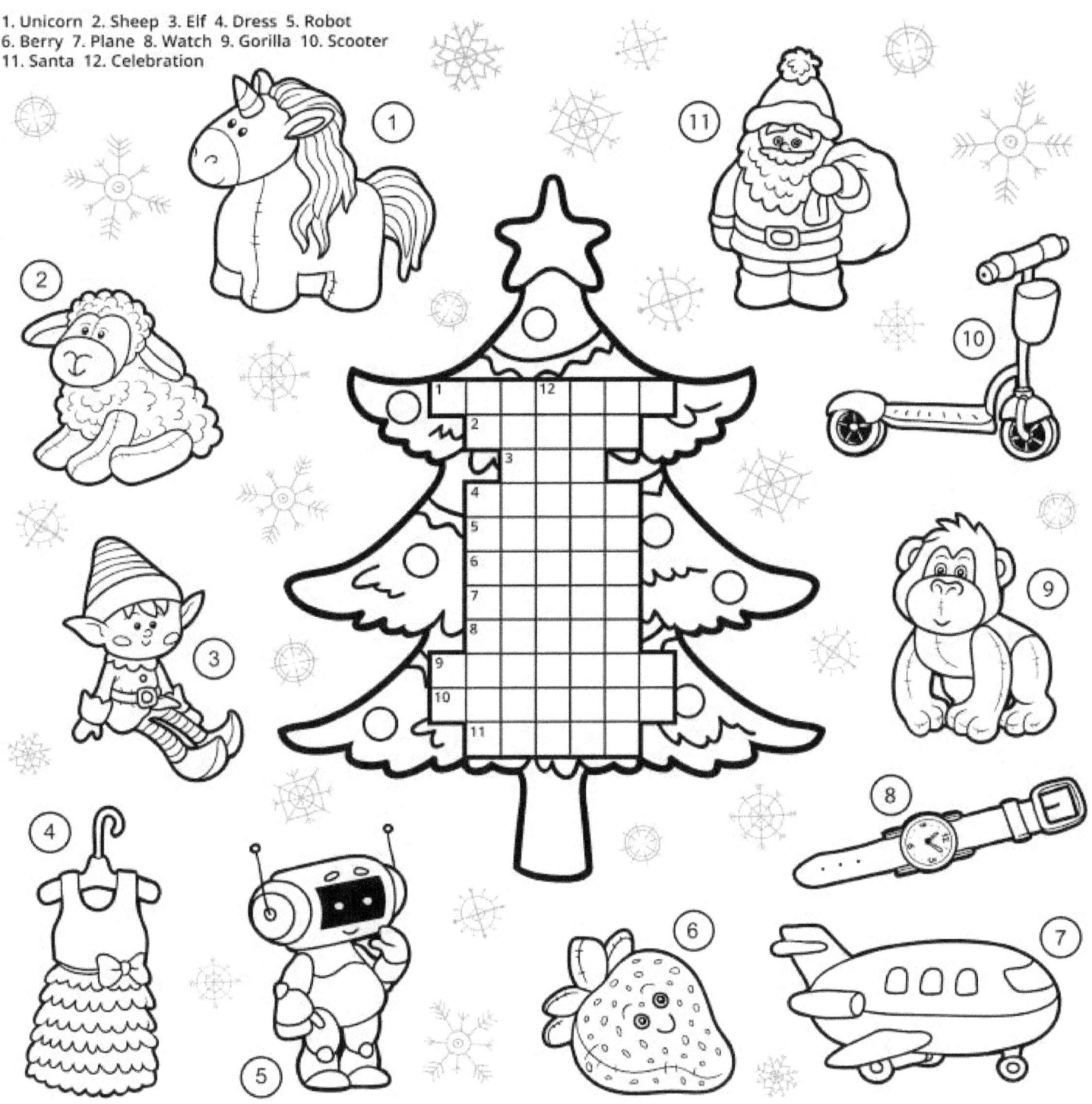

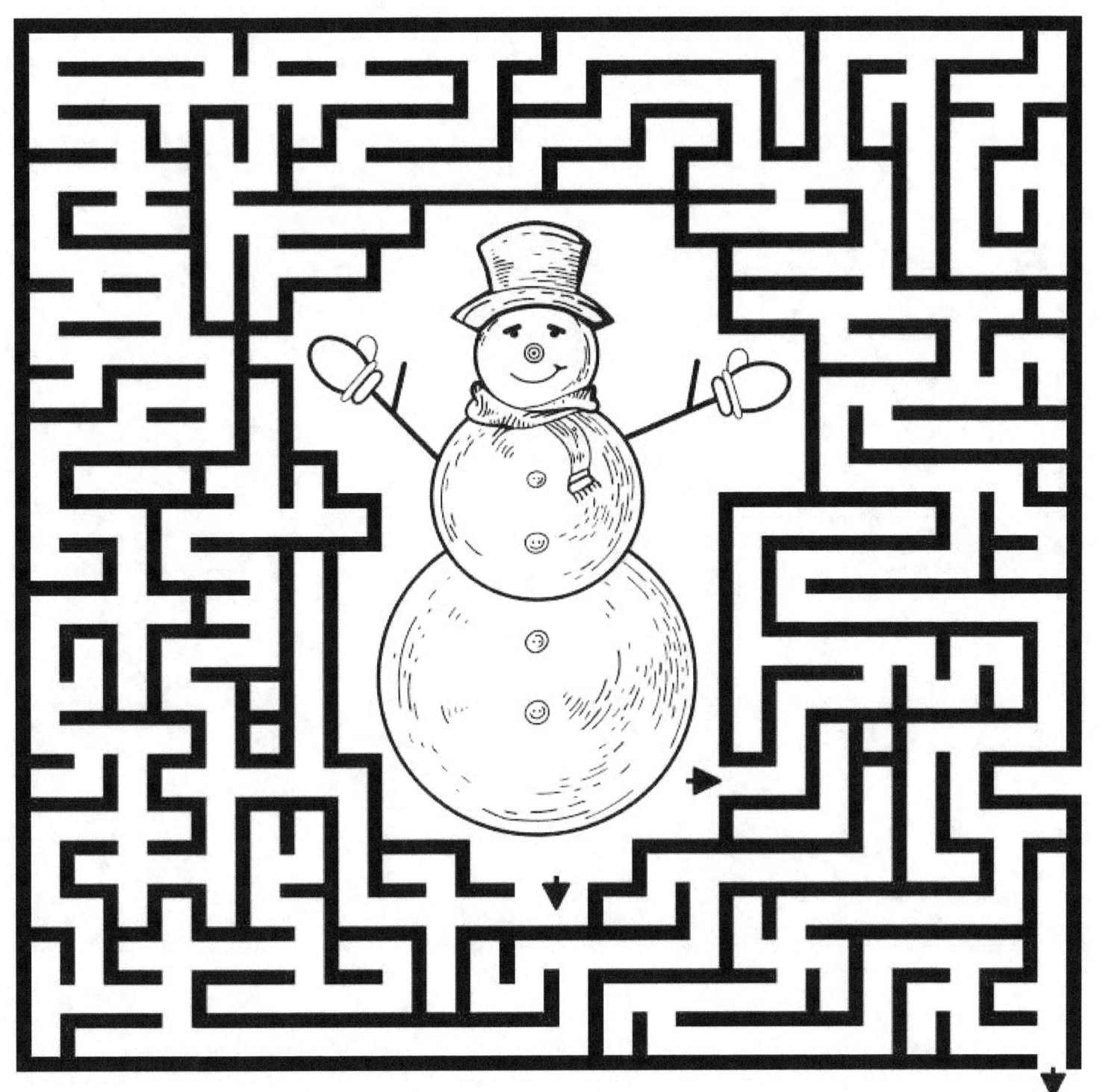

Find two the same pictures

Find two the same pictures

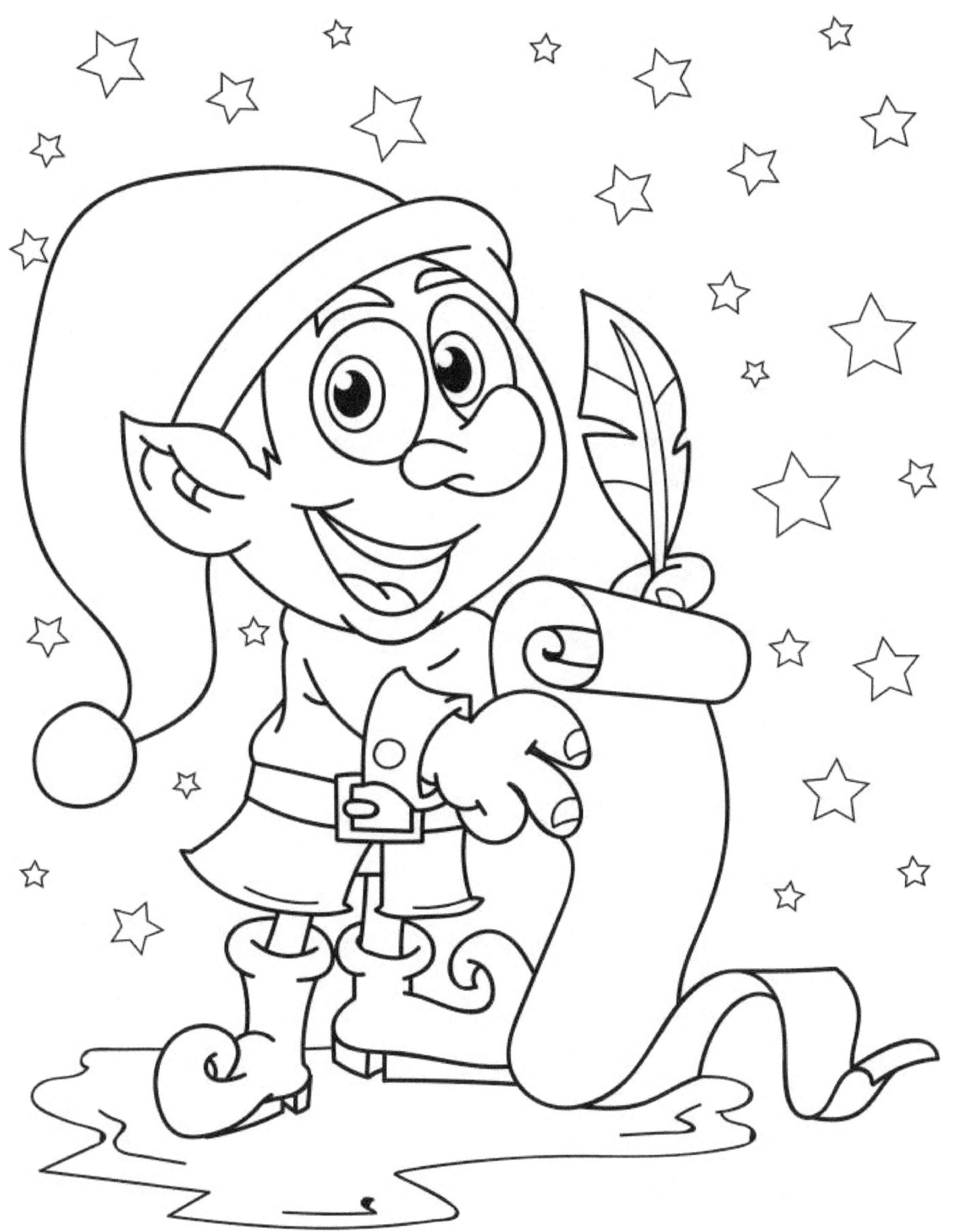

www.ingramcontent.com/pod-product-compliance
Lightning Source LLC
Chambersburg PA
CBHW080815220526
45466CB00011BB/3573